MOMMY'S SWEAR WORDS

Coloring2Relax

Copyright © 2017 by Coloring2Relax

All rights reserved. No part of this publication may be reproduced, distributed or transmitted in any form or by any means, including photocopying, recording or any other electronic or mechanical methods, without the prior written permission of the publisher, except in the case of brief quotations embodied in critical reviews and certain other noncommercial uses permitted by copyright law. For permission requests, contact the publisher, with "Attention: Permissions Coordinator" in the subject field, at the email address listed below.

Coloring2Relax Publishing

support@coloring2relax.com

Printed in the United States of America

First Printing, 2017

http://www.coloring2relax.com

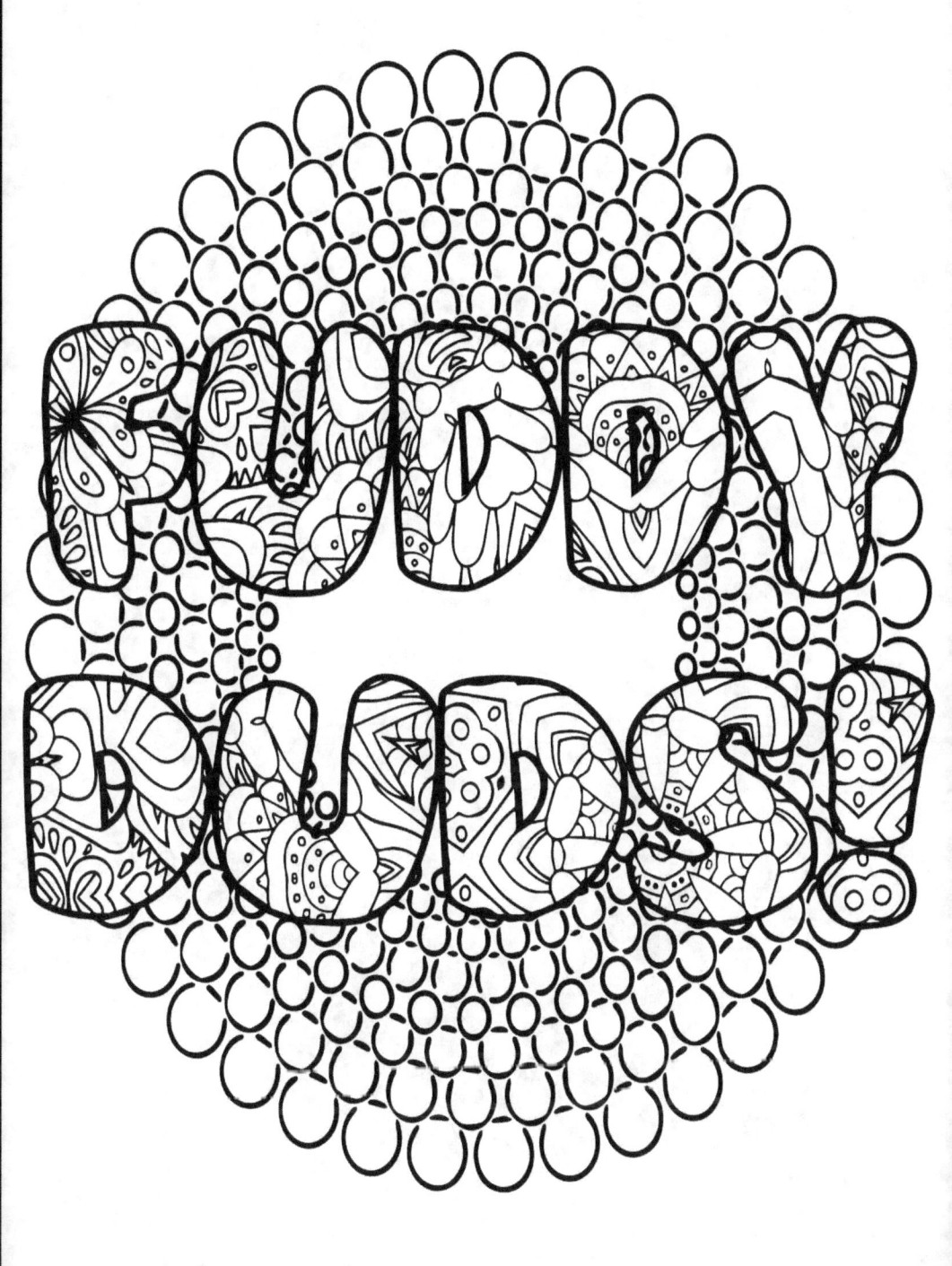

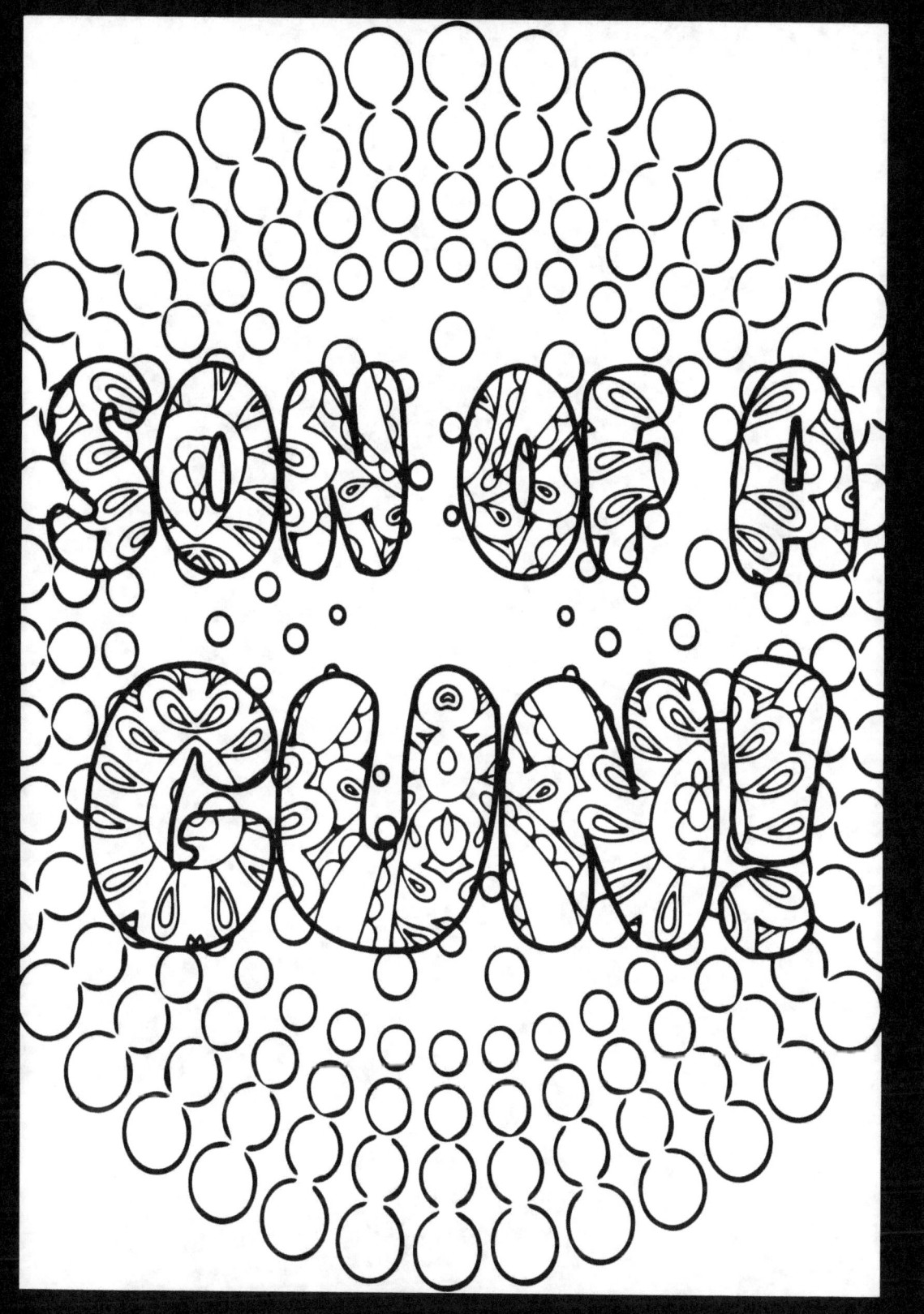

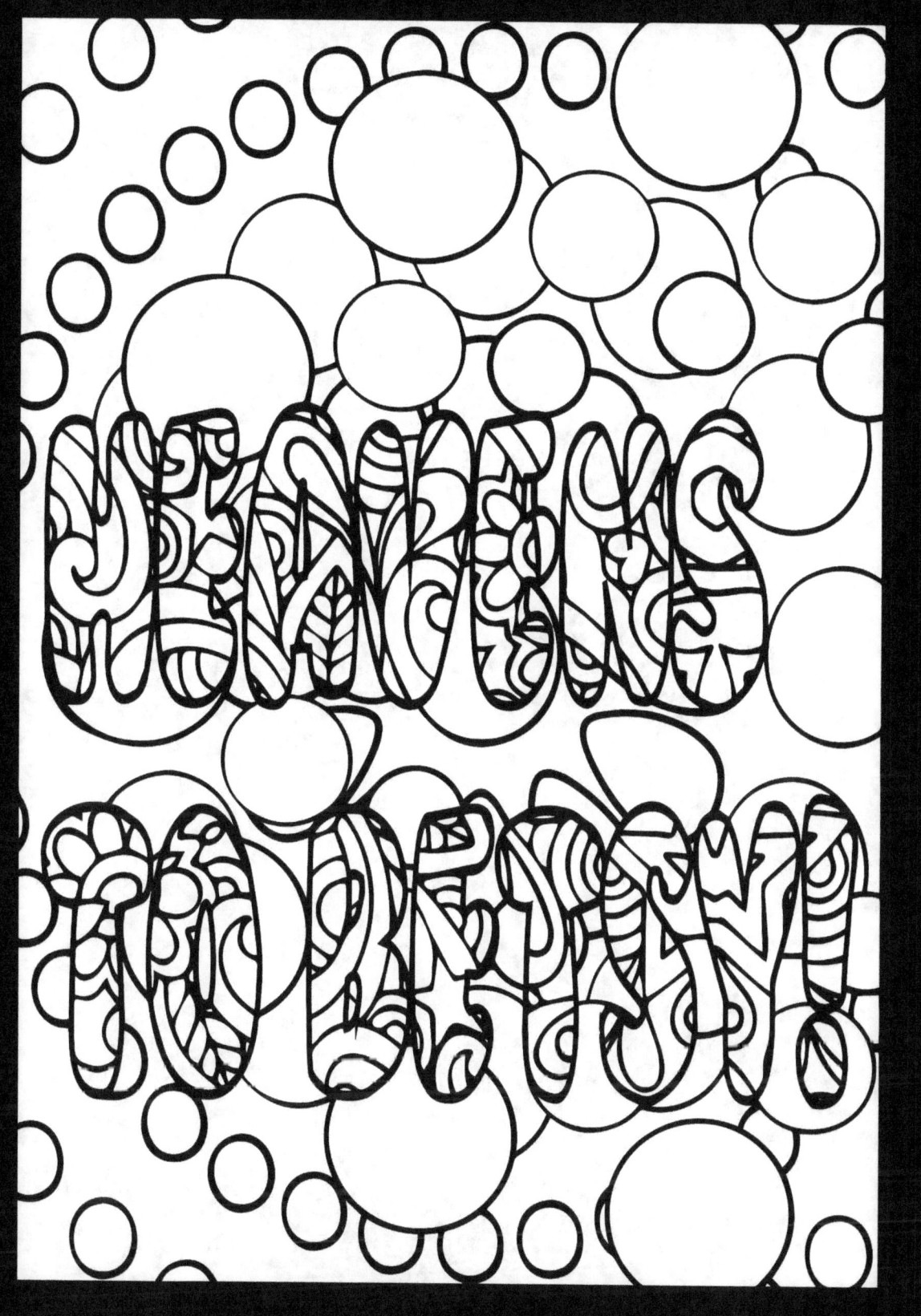

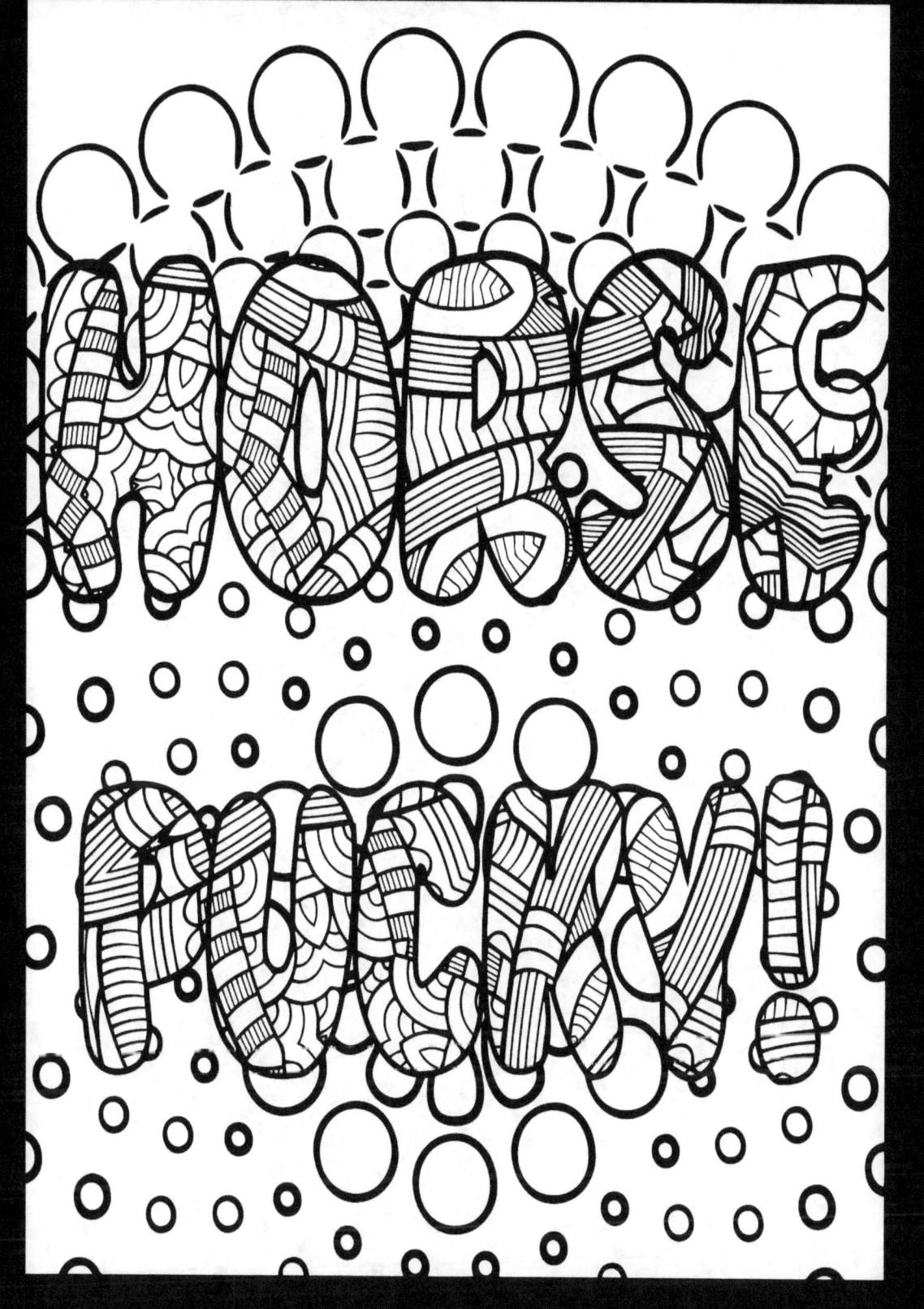

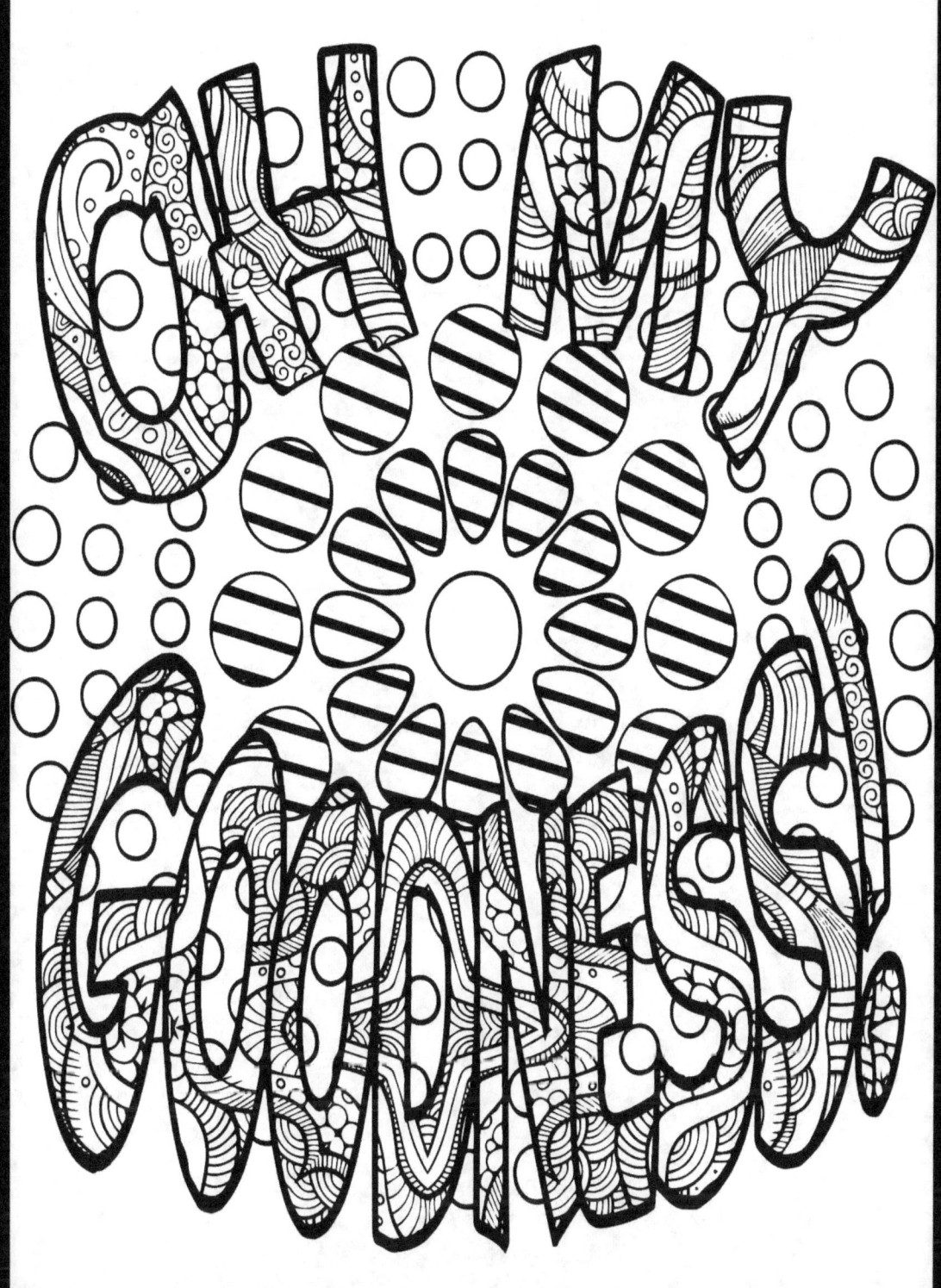

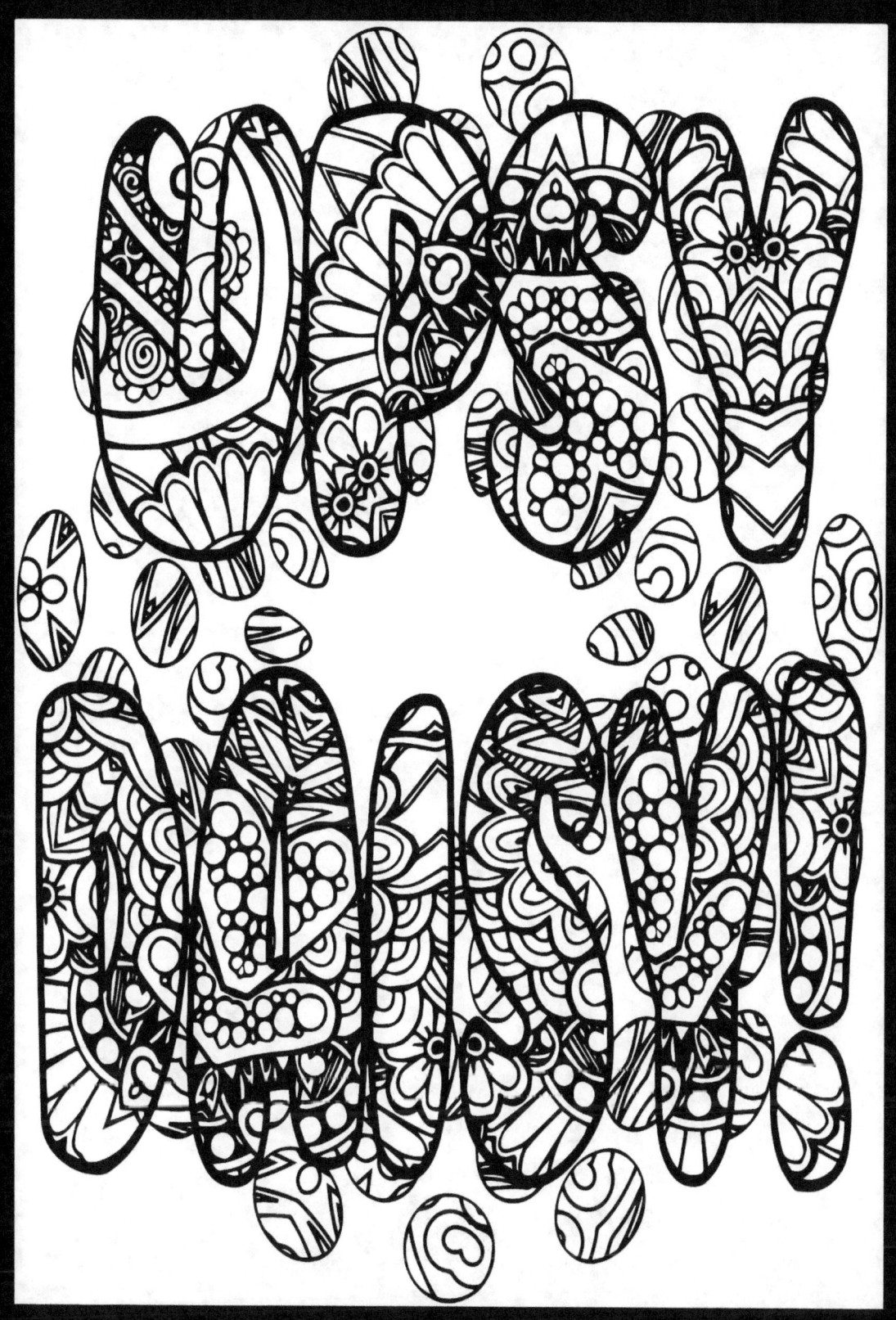

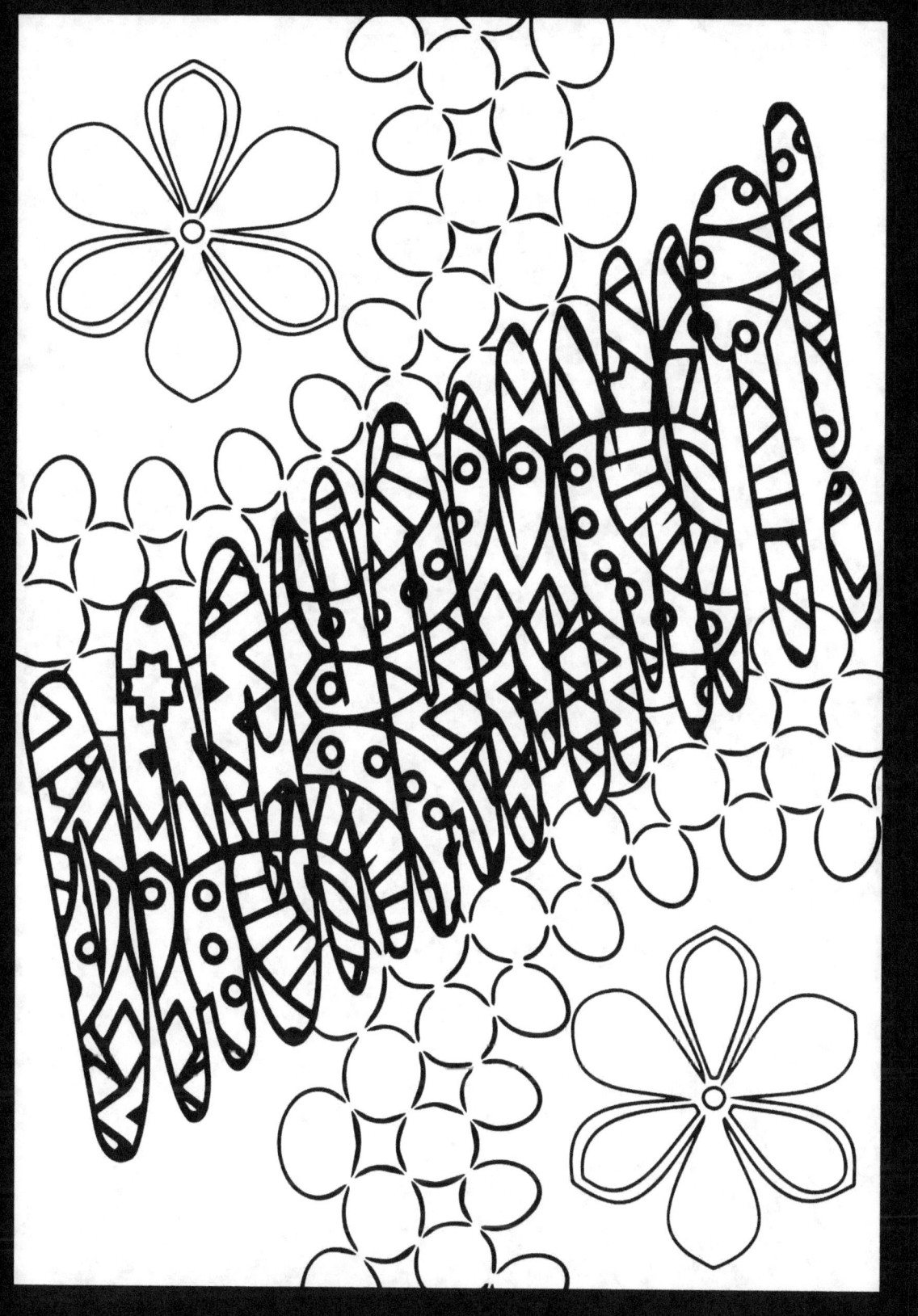

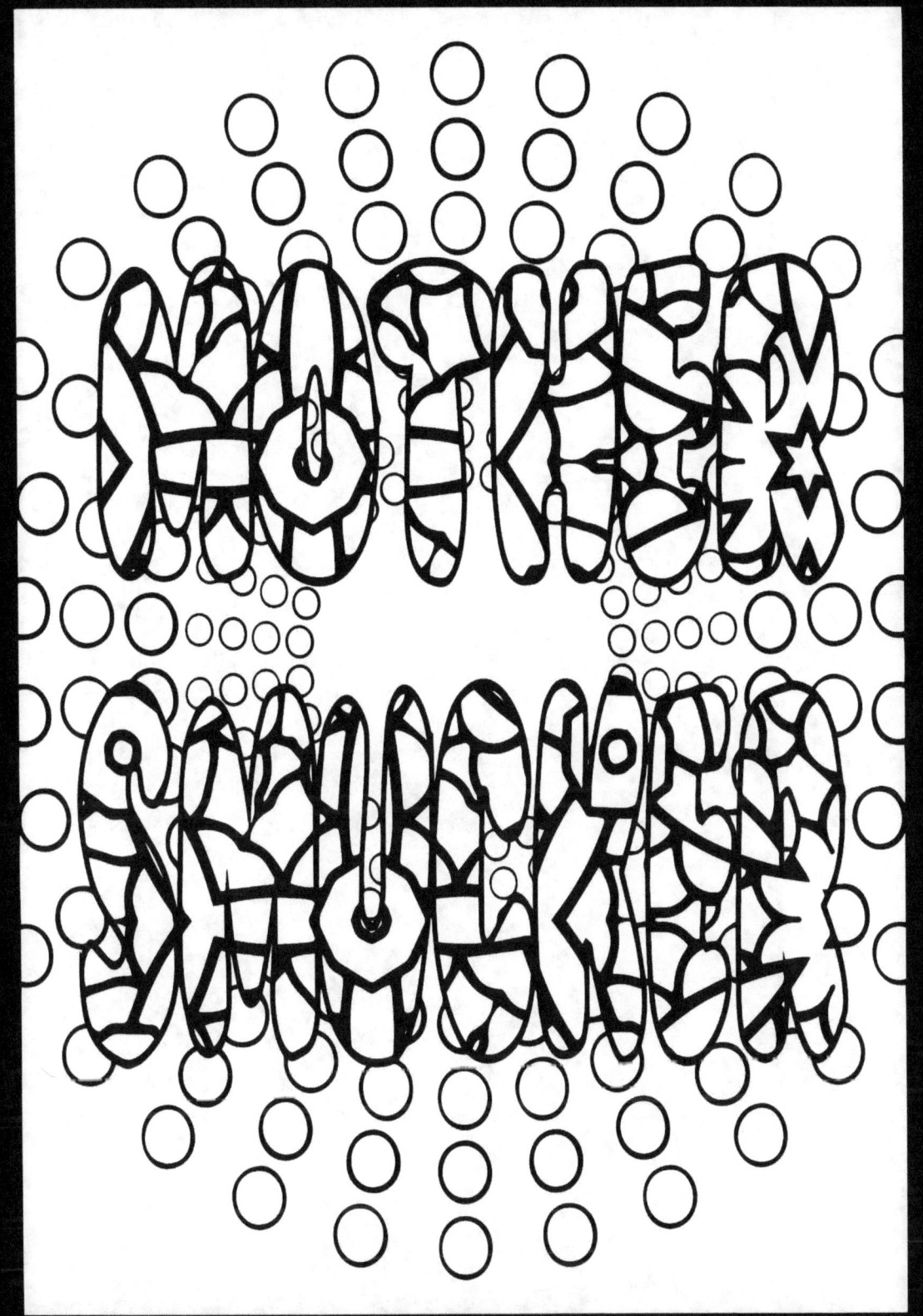

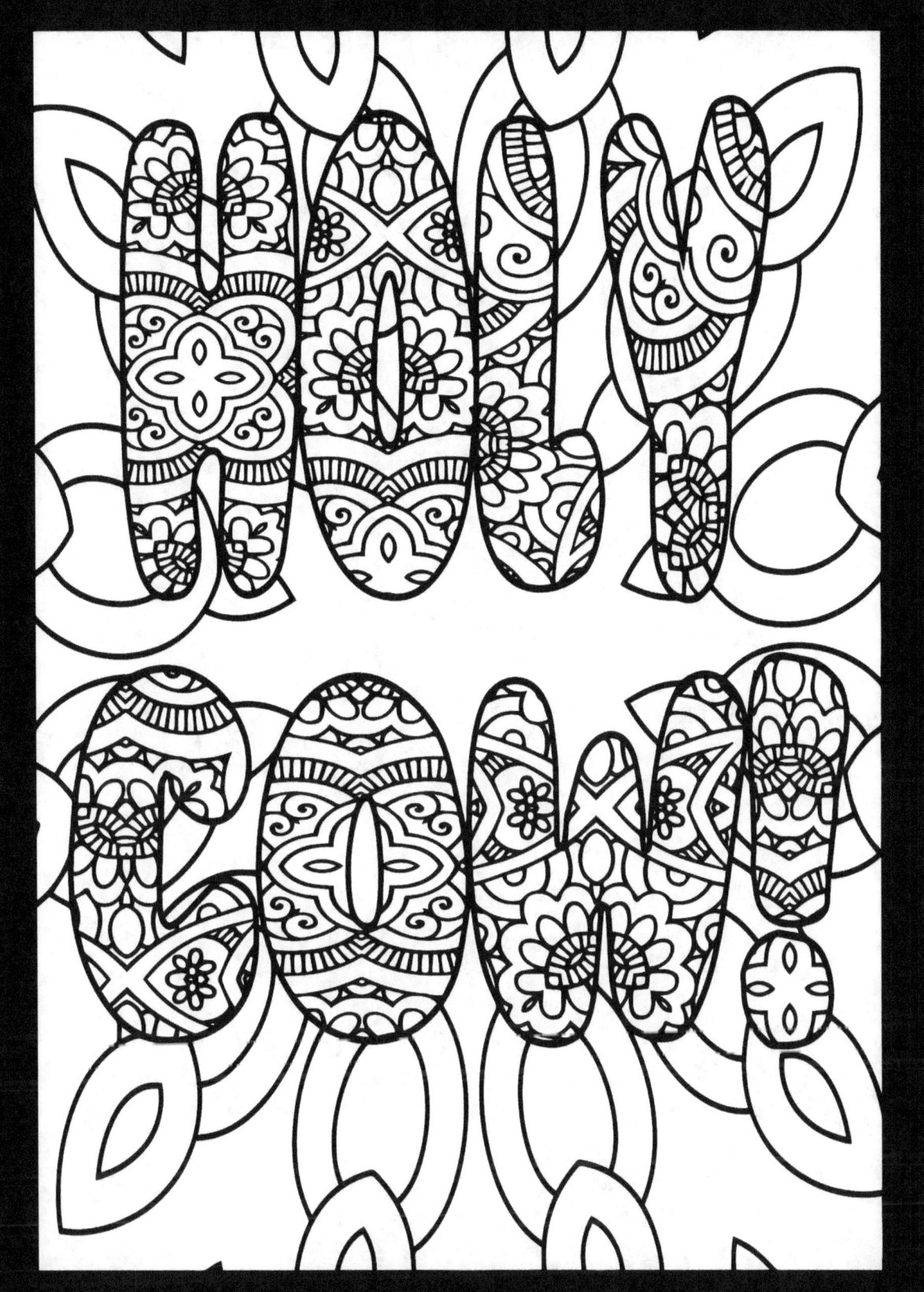

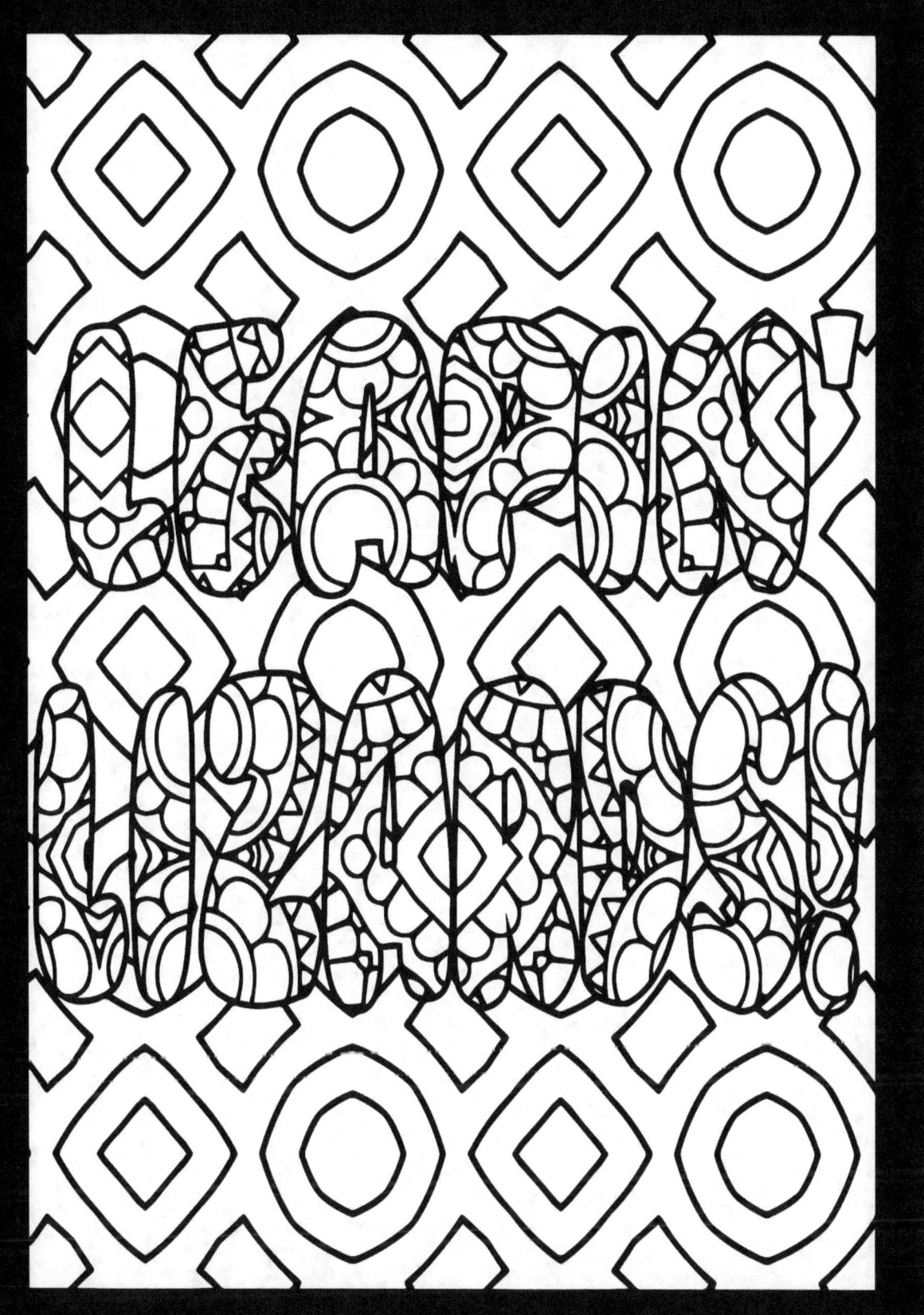

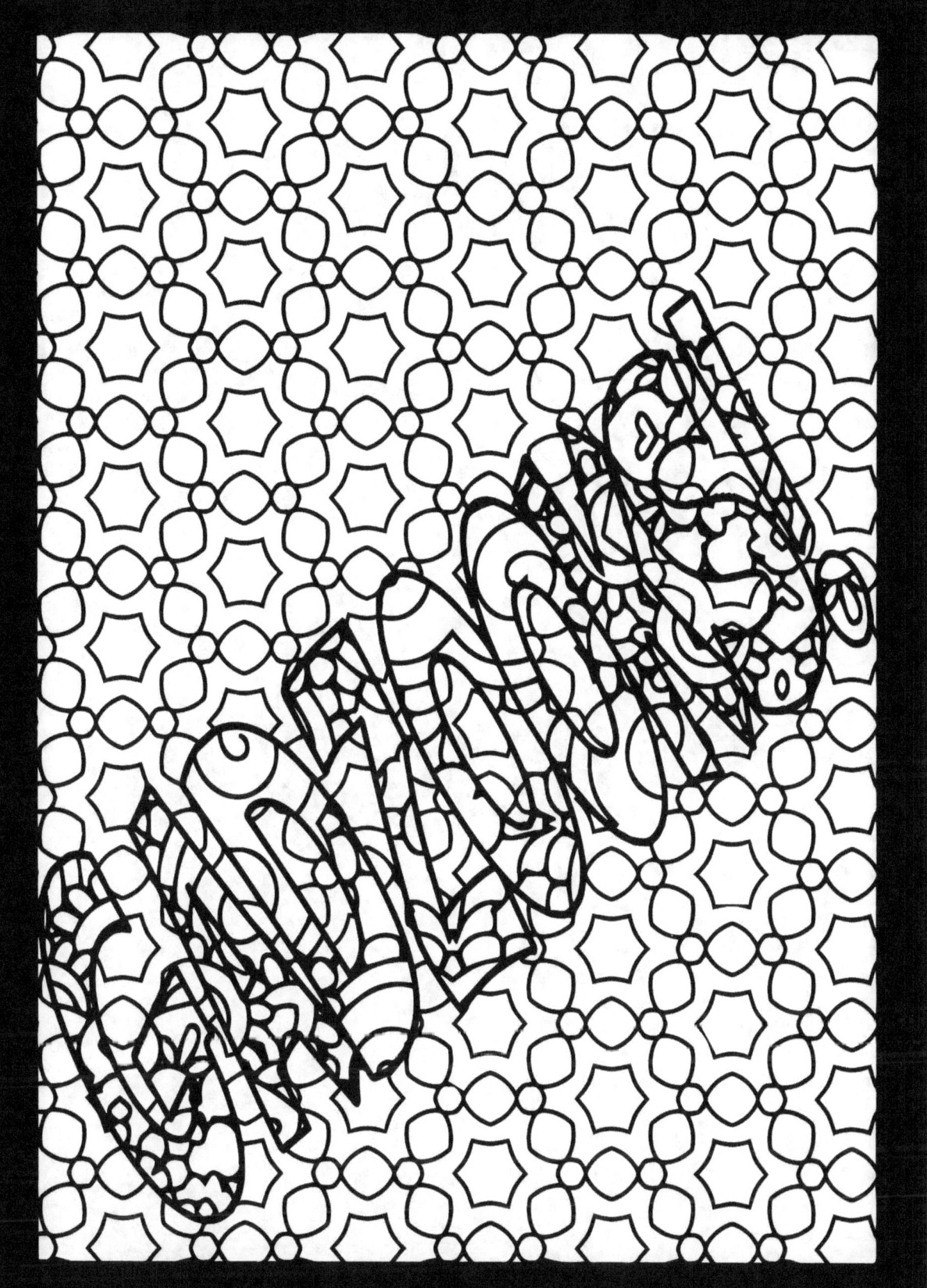

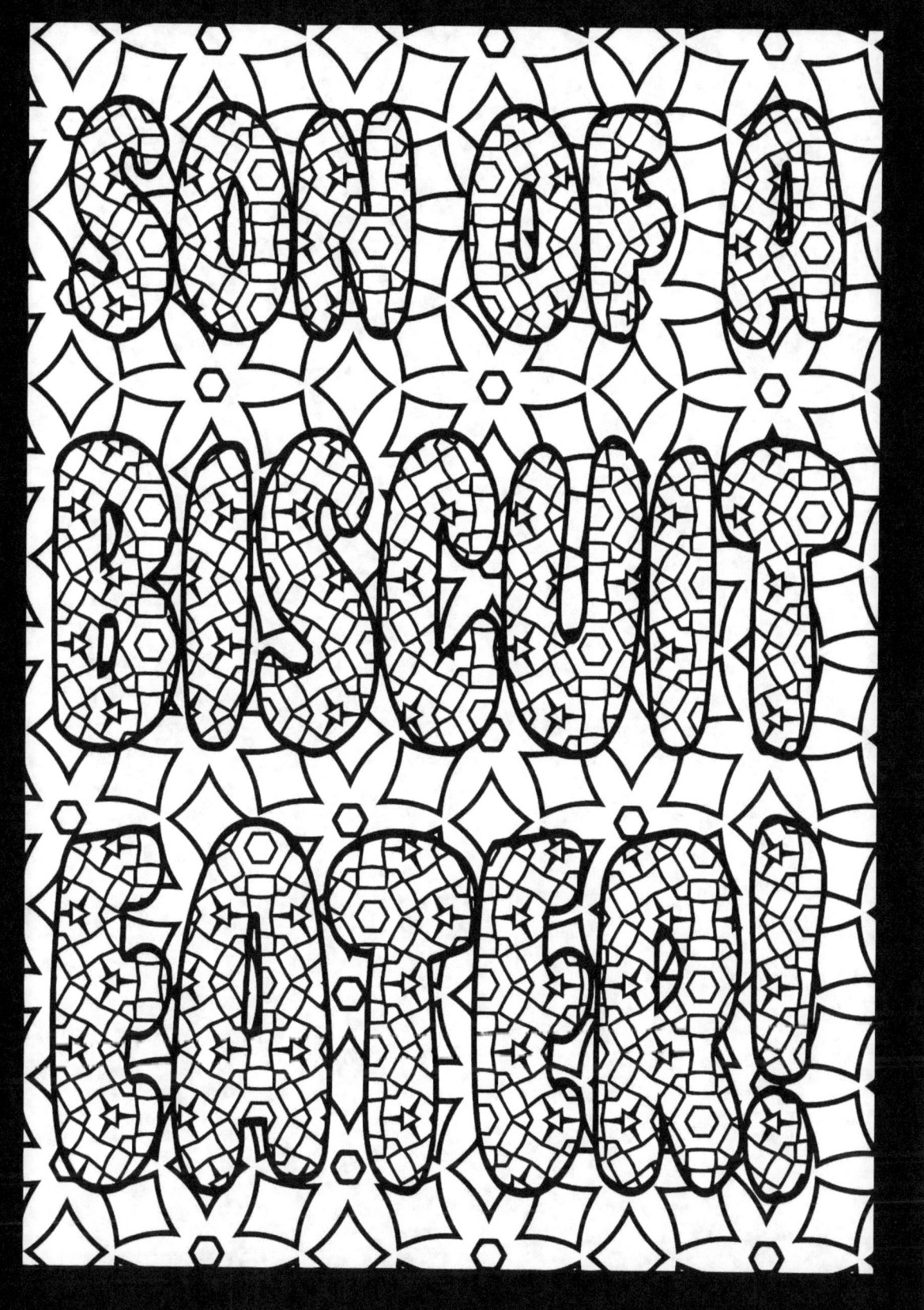

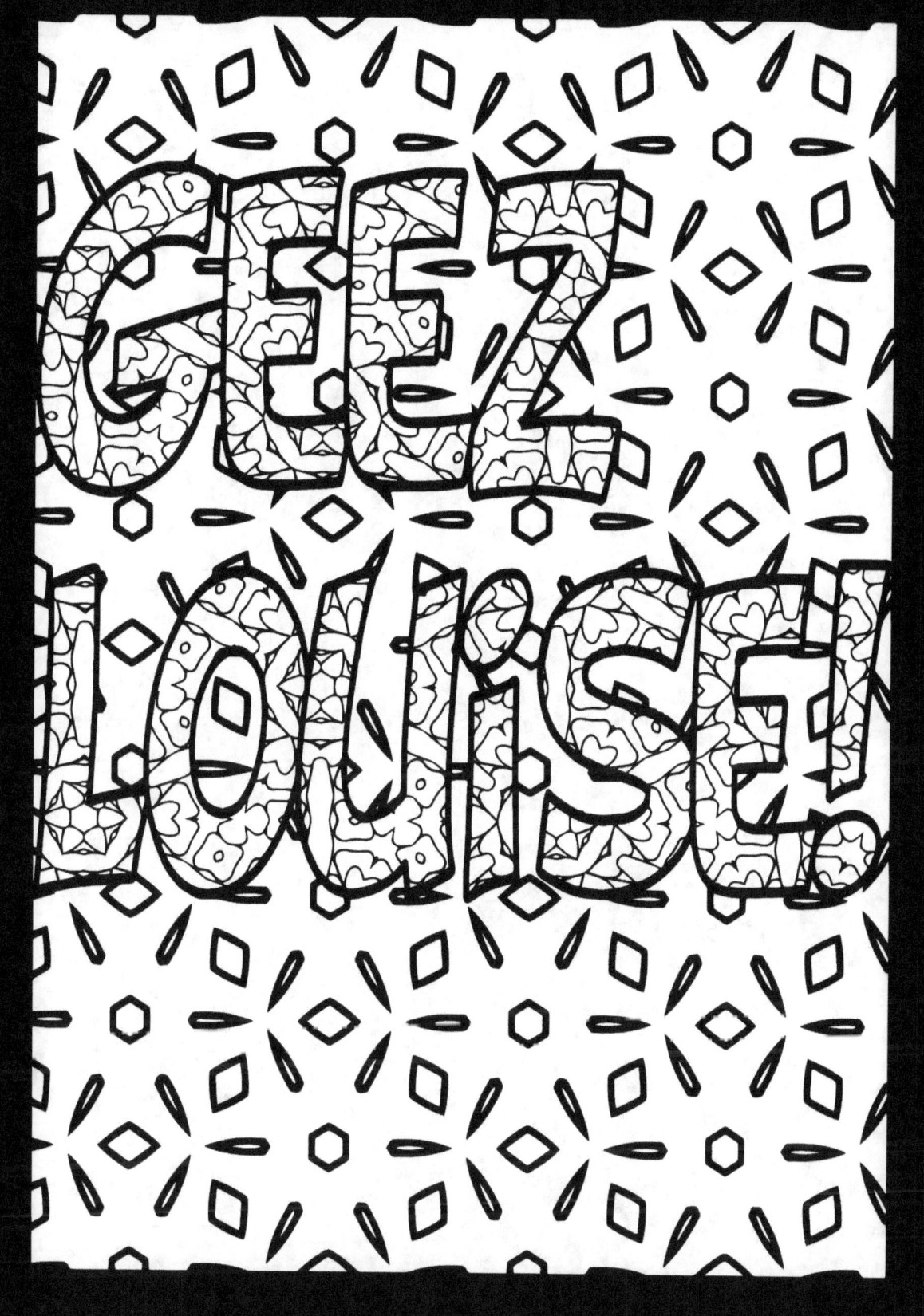

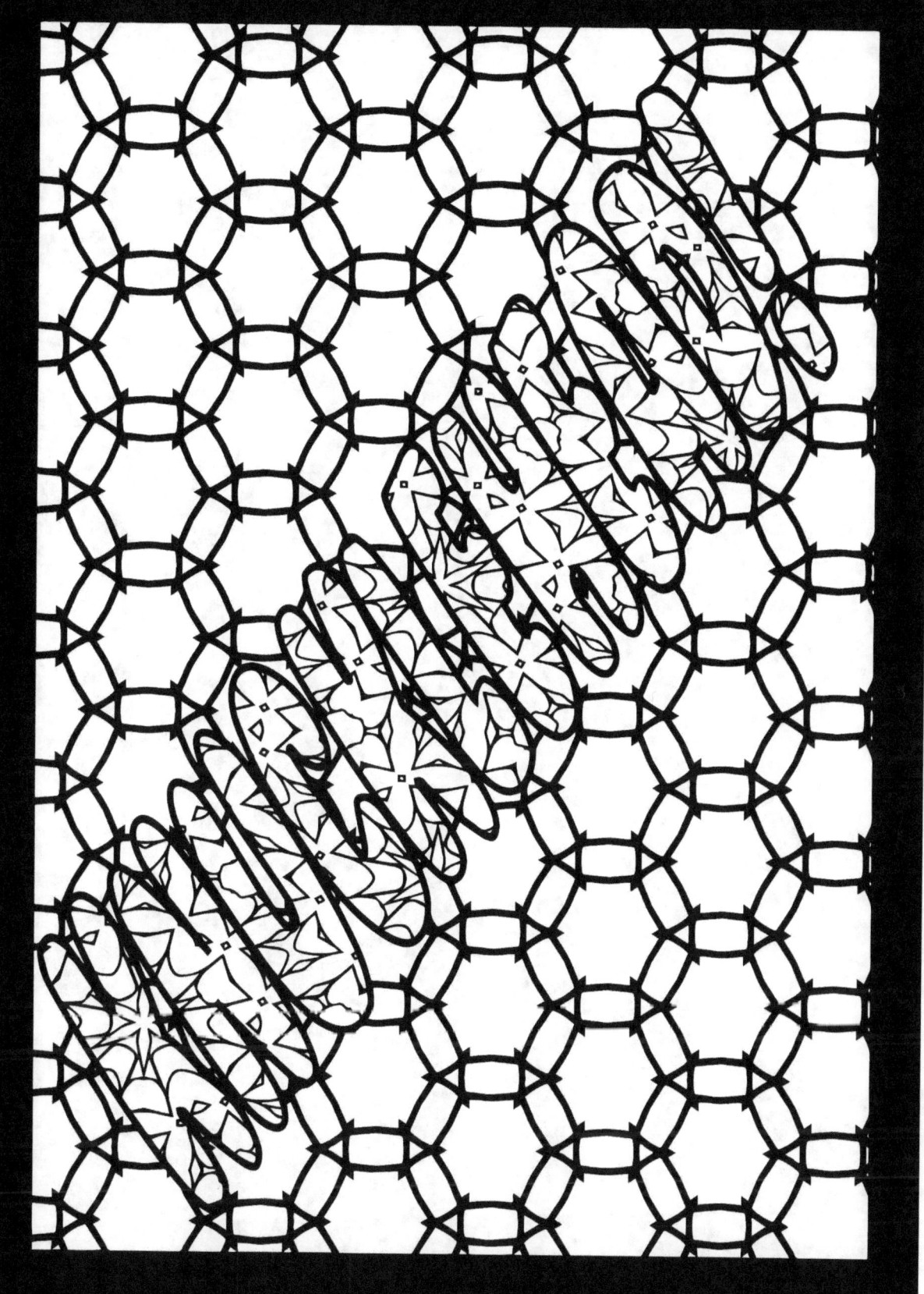

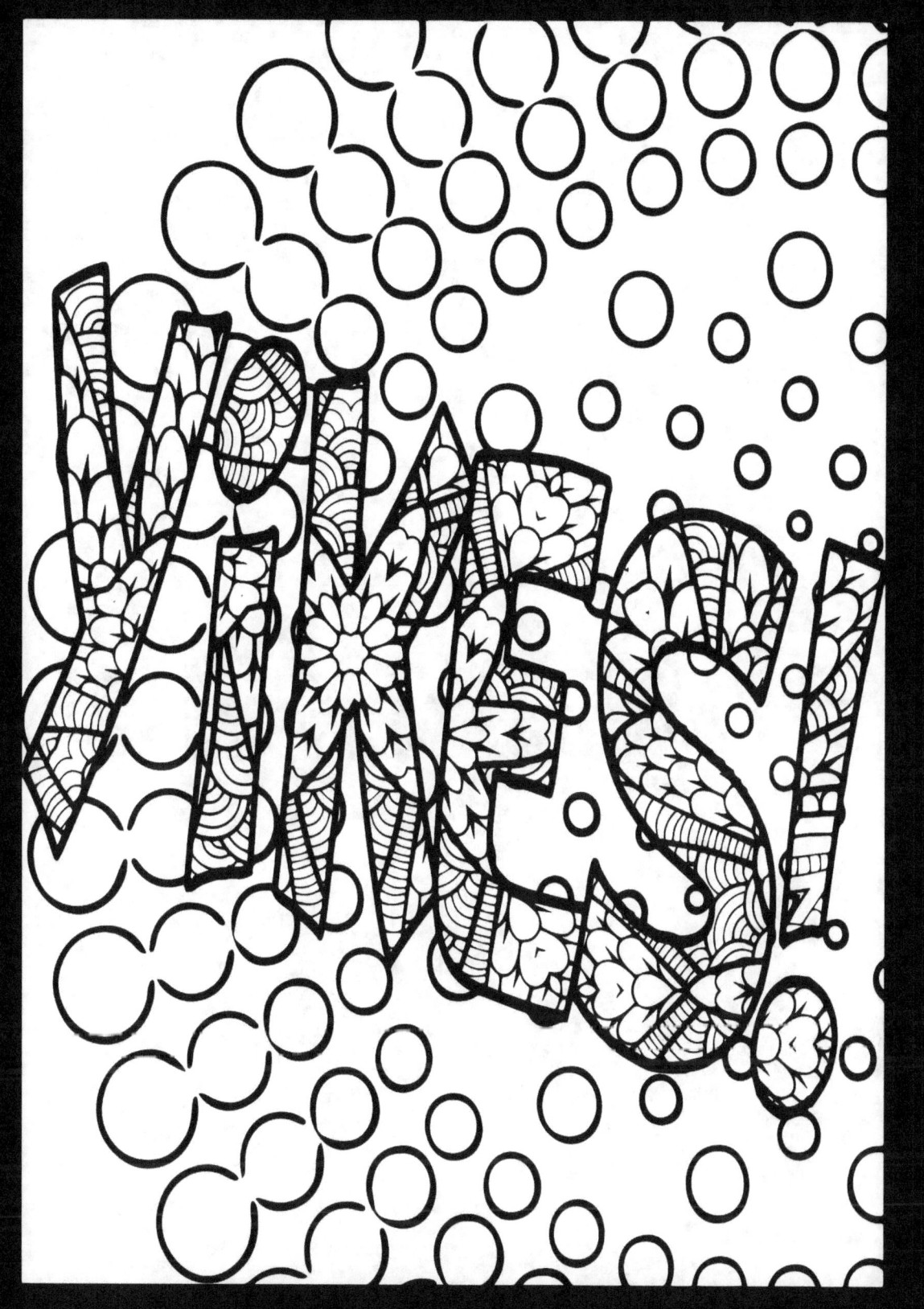

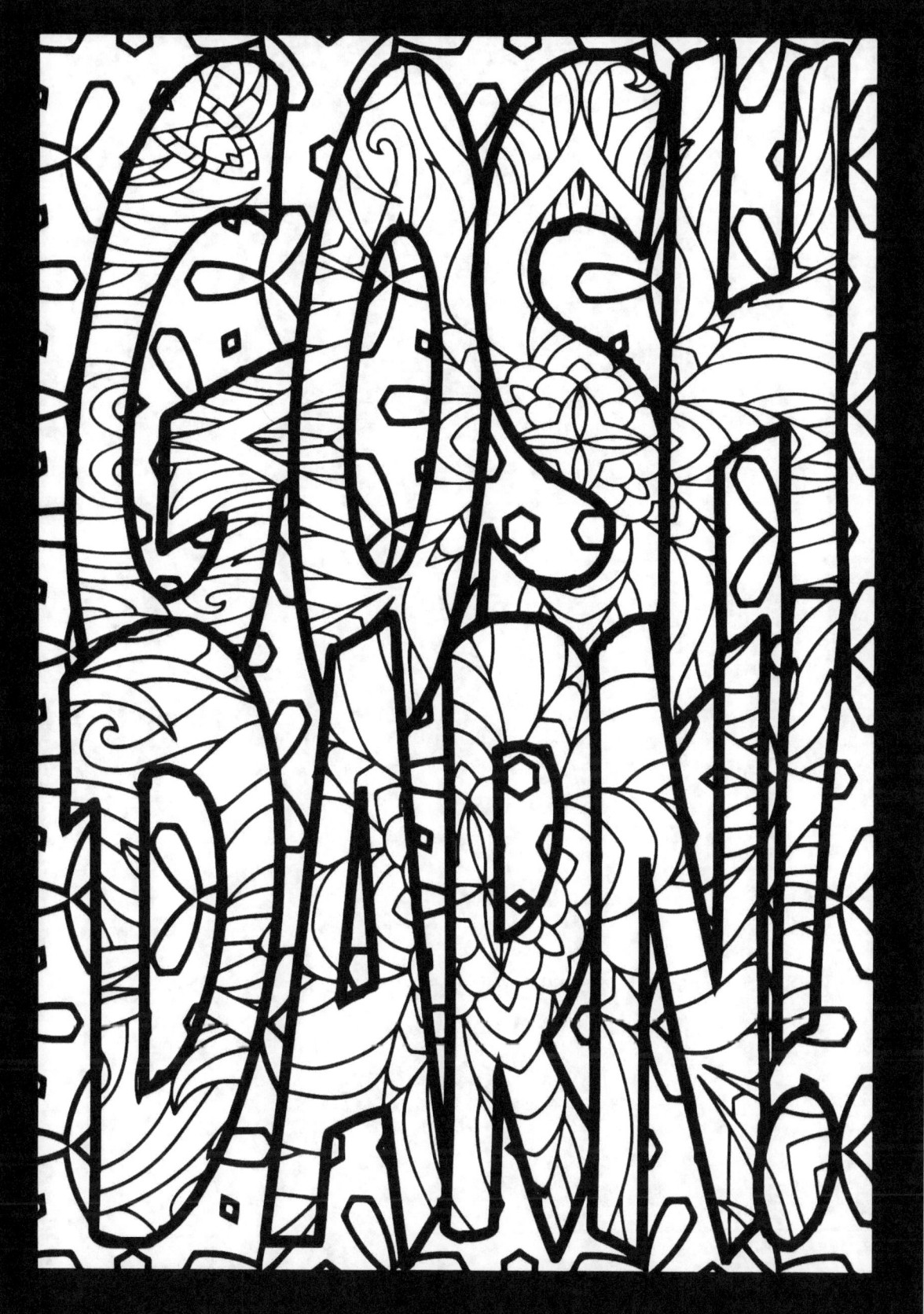

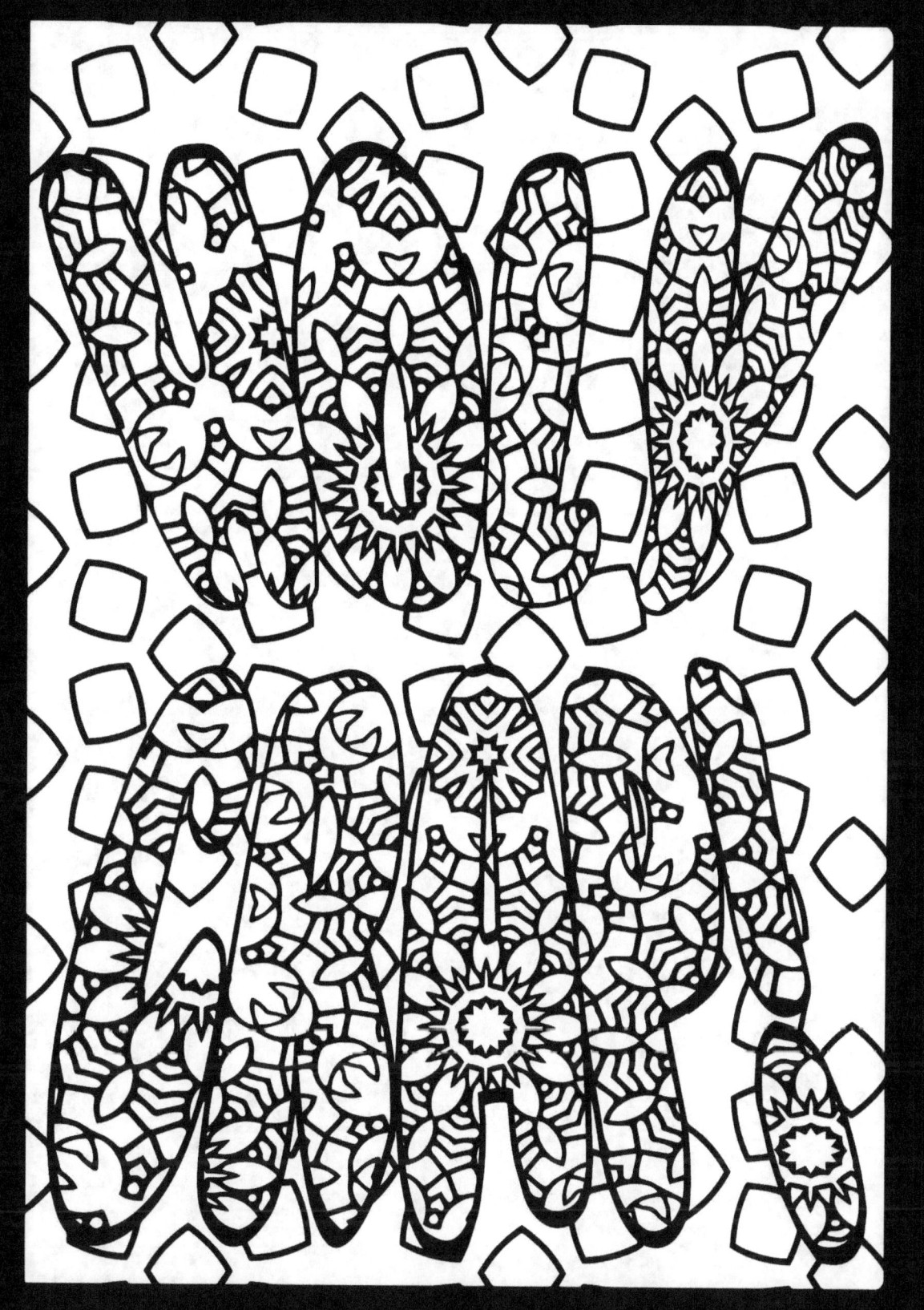

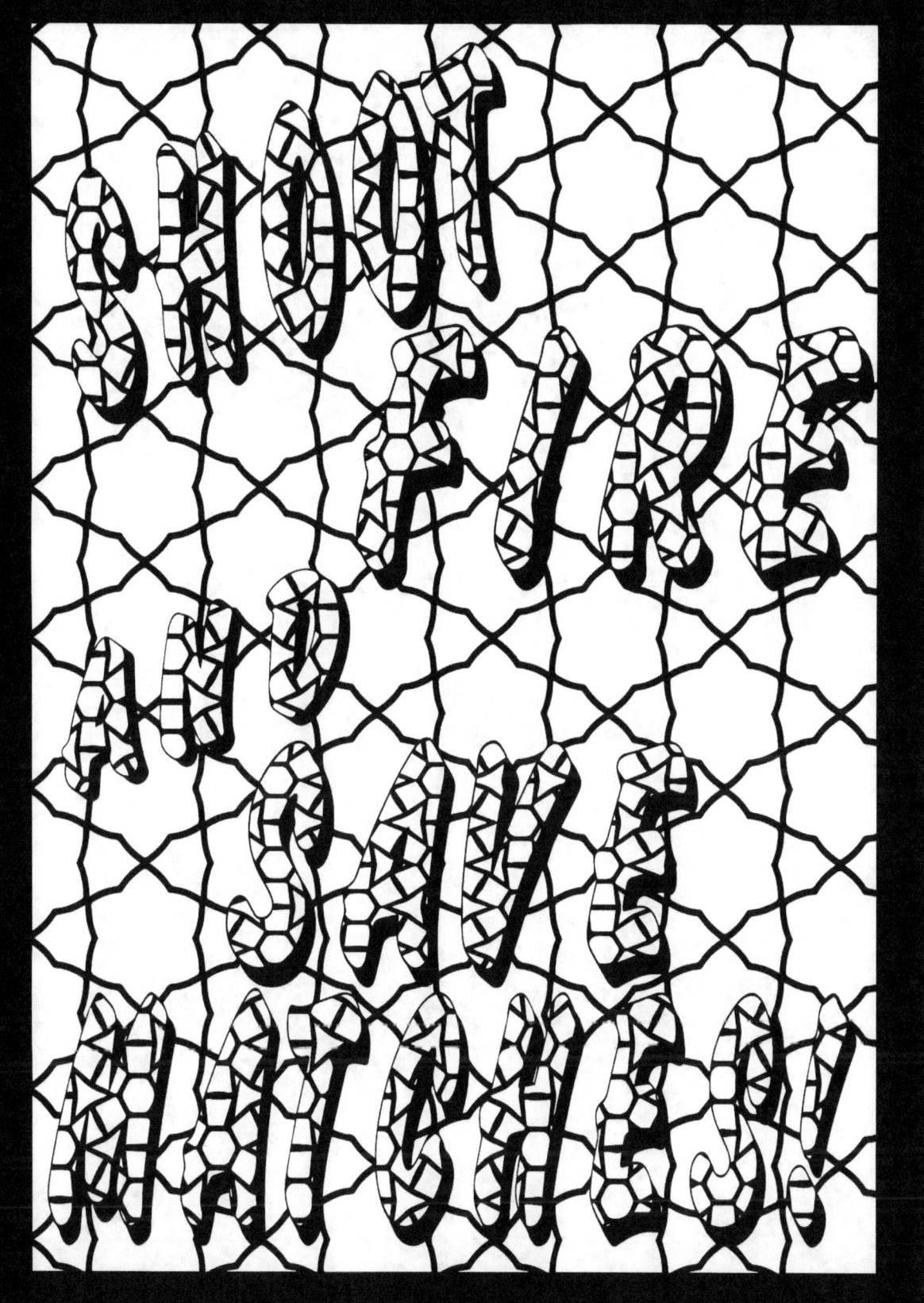

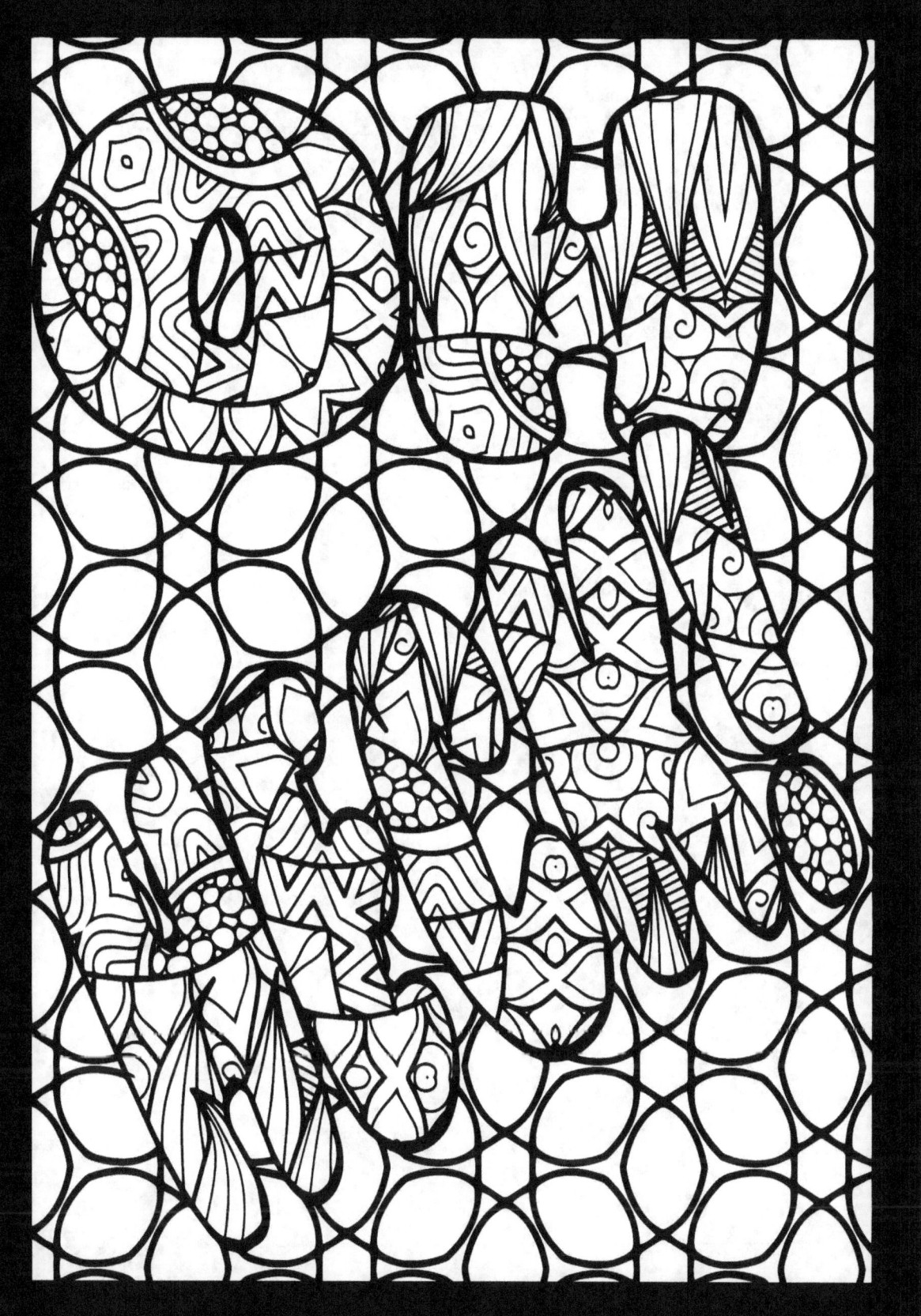

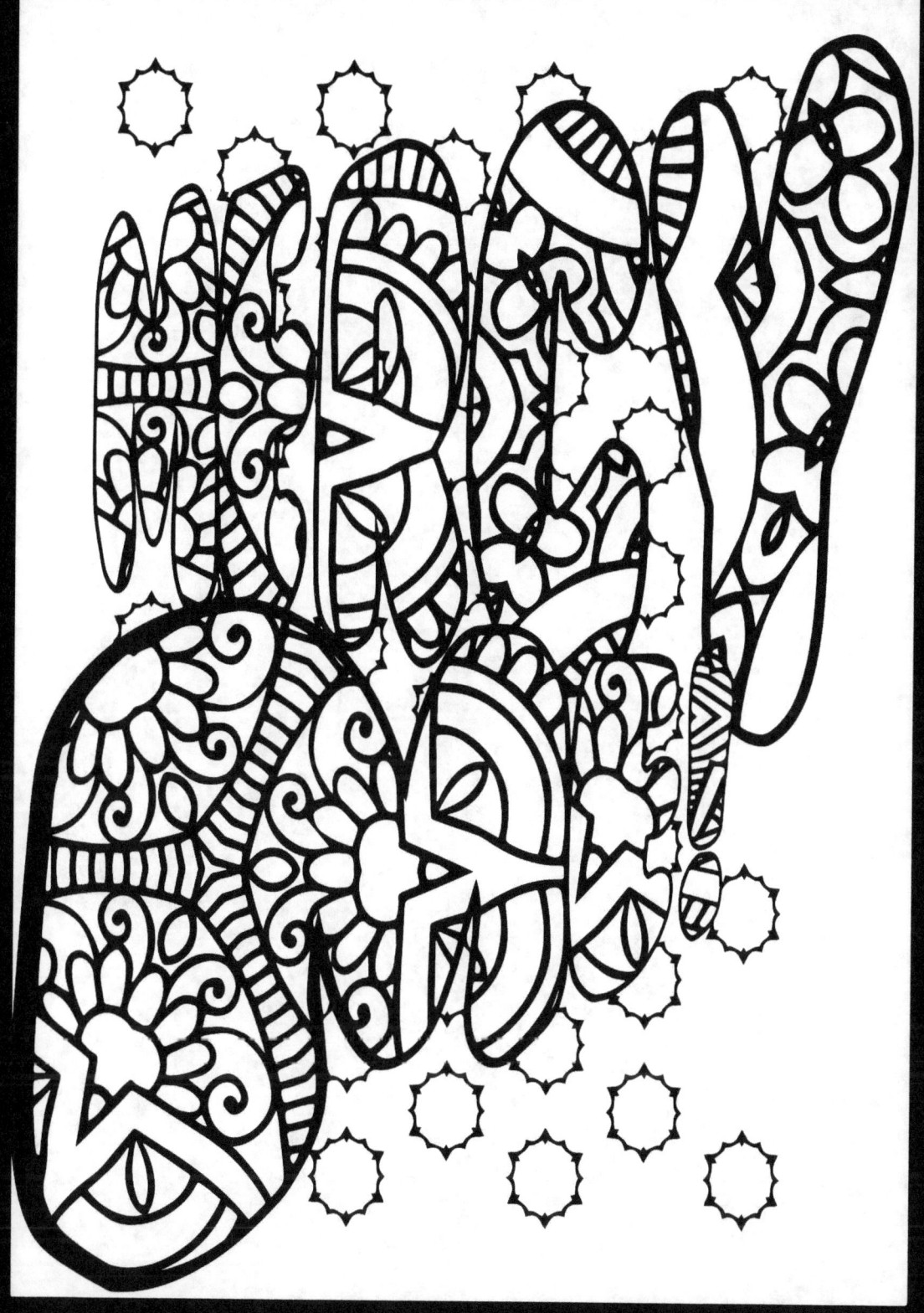

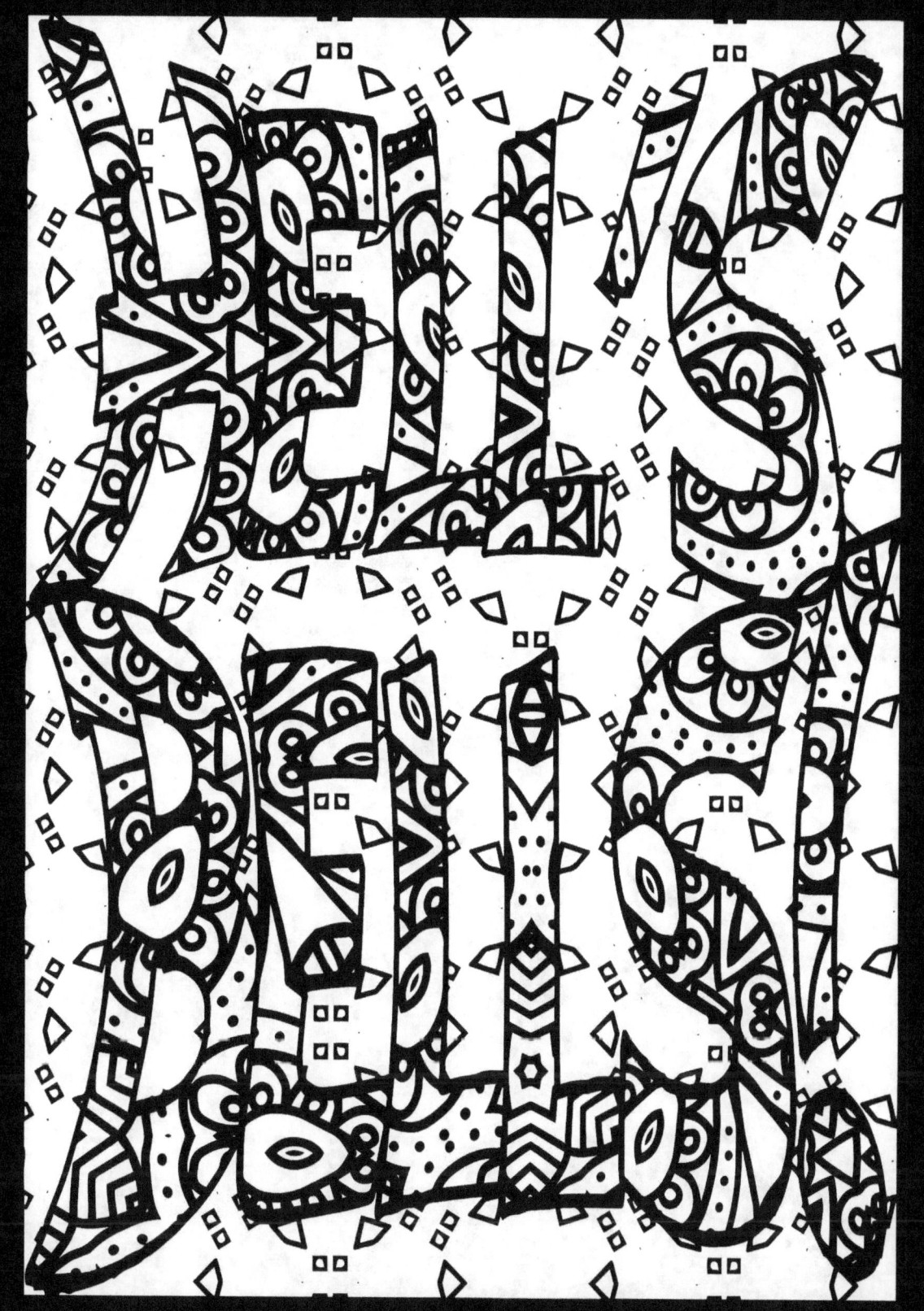

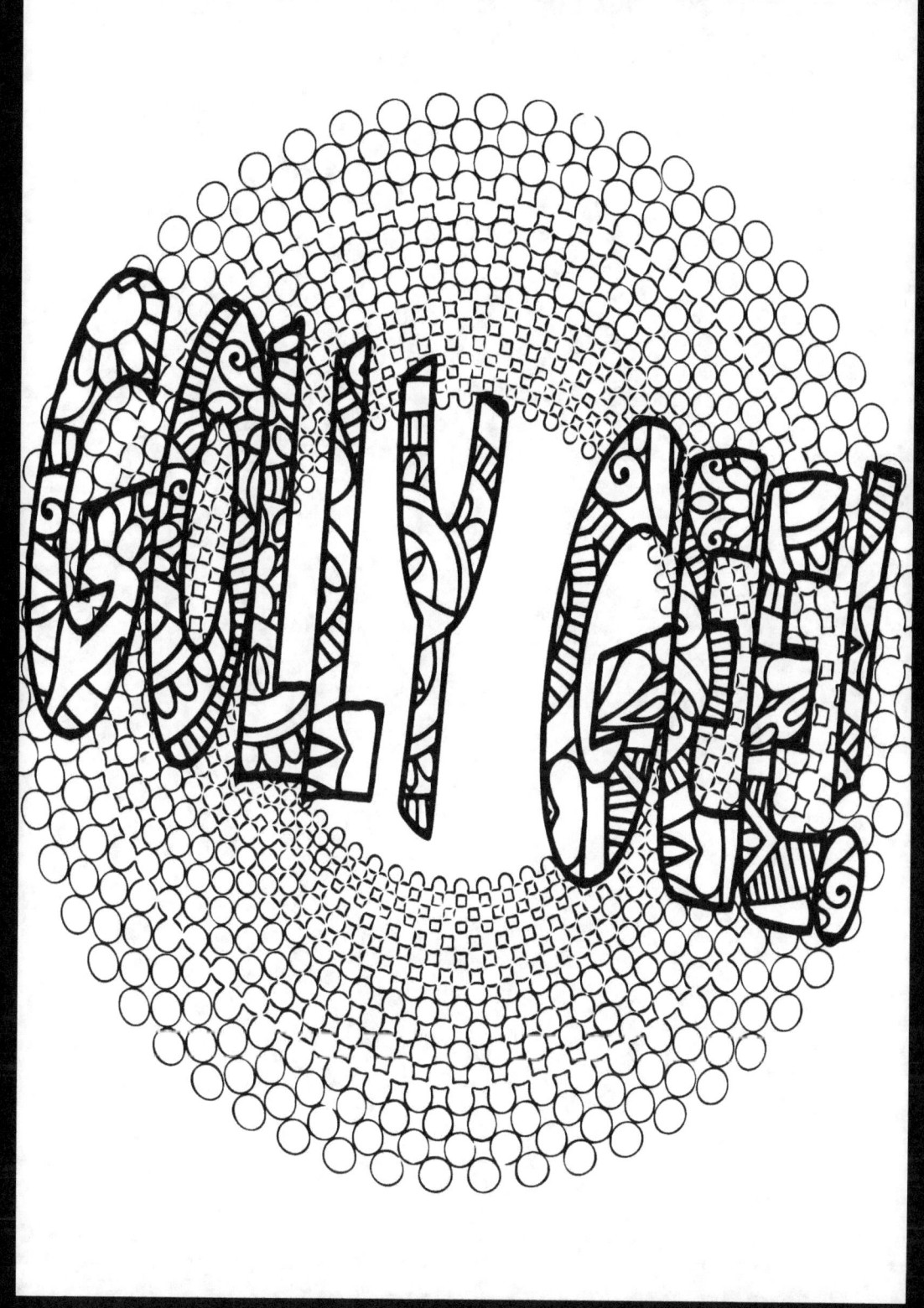

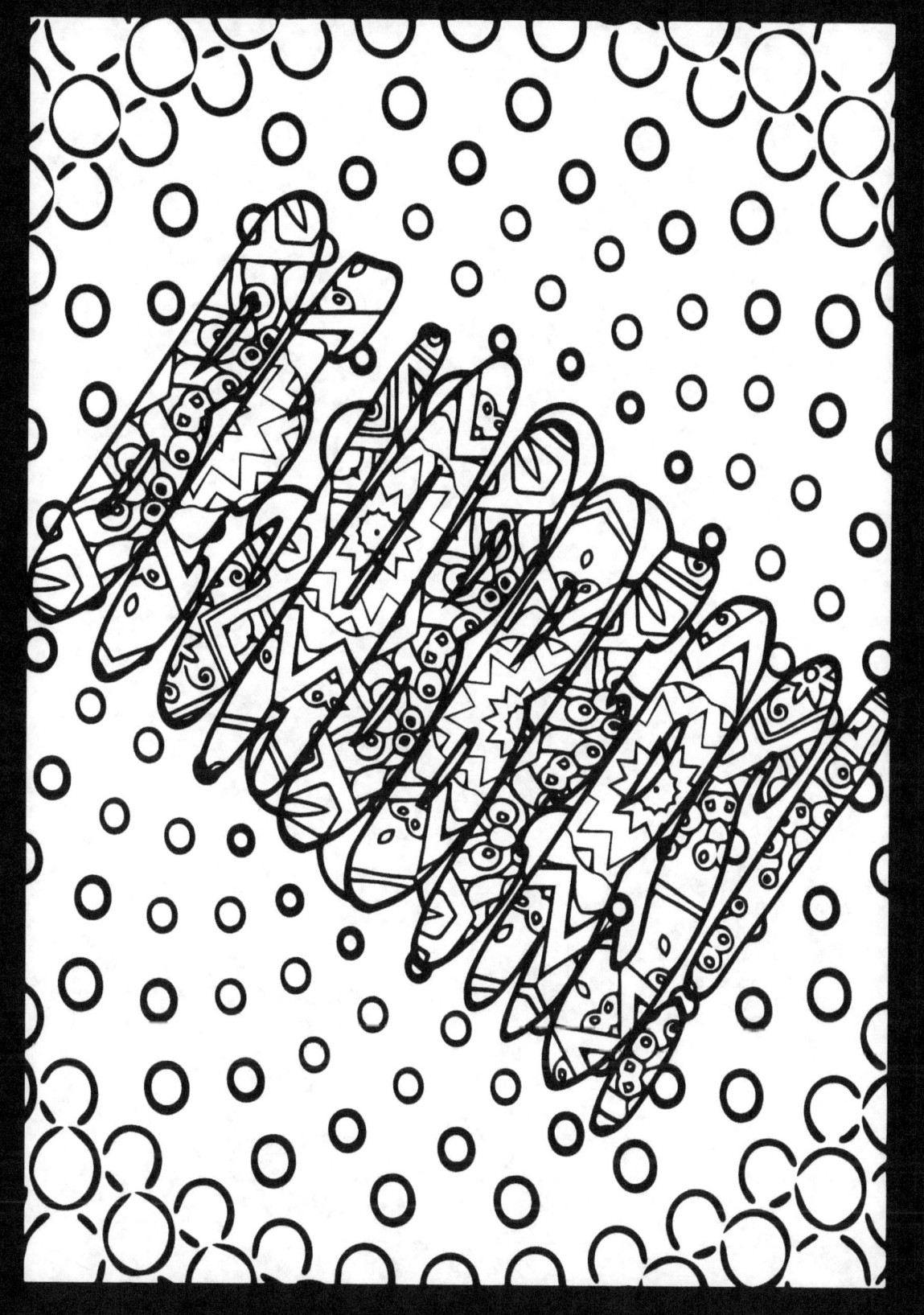

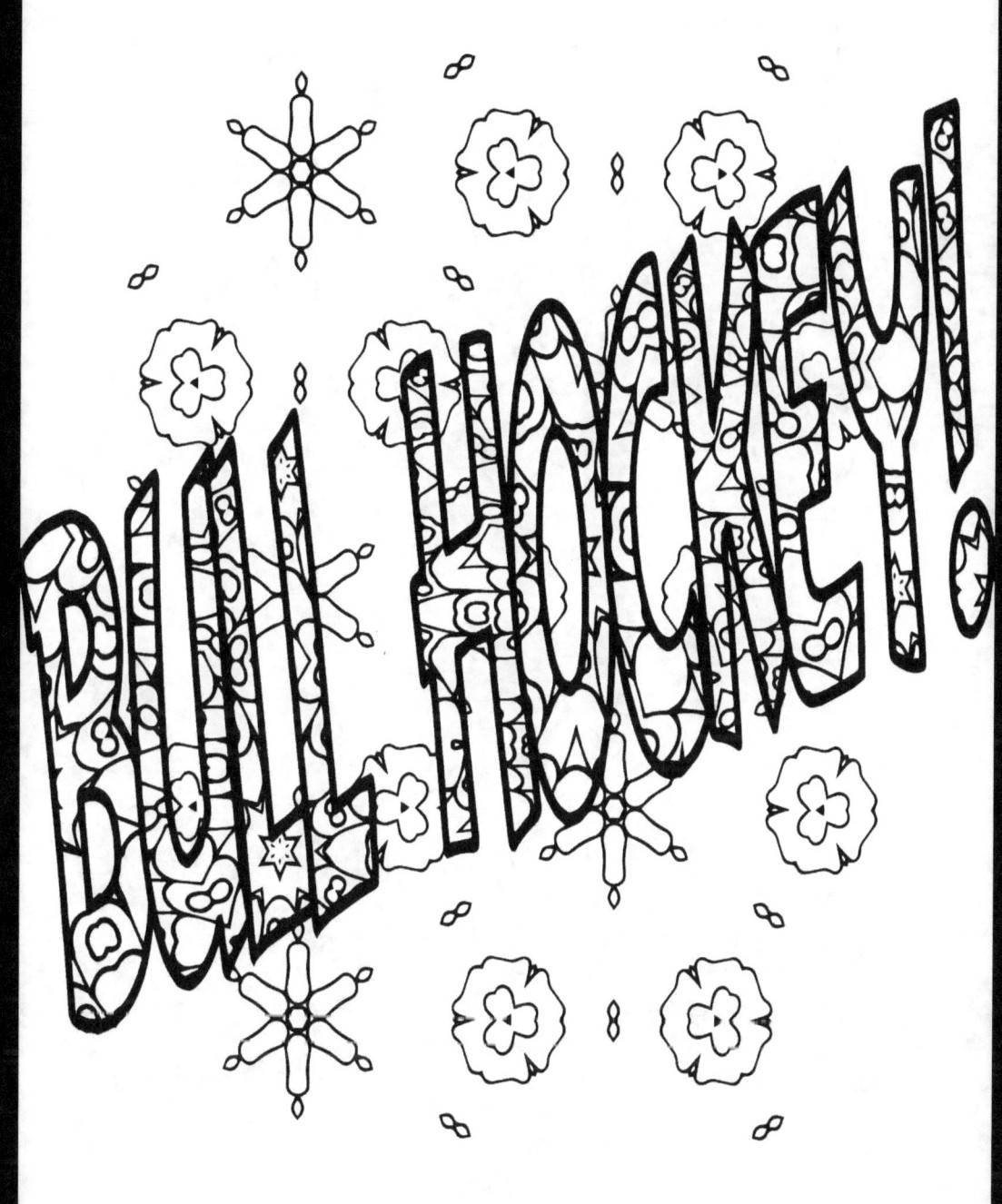

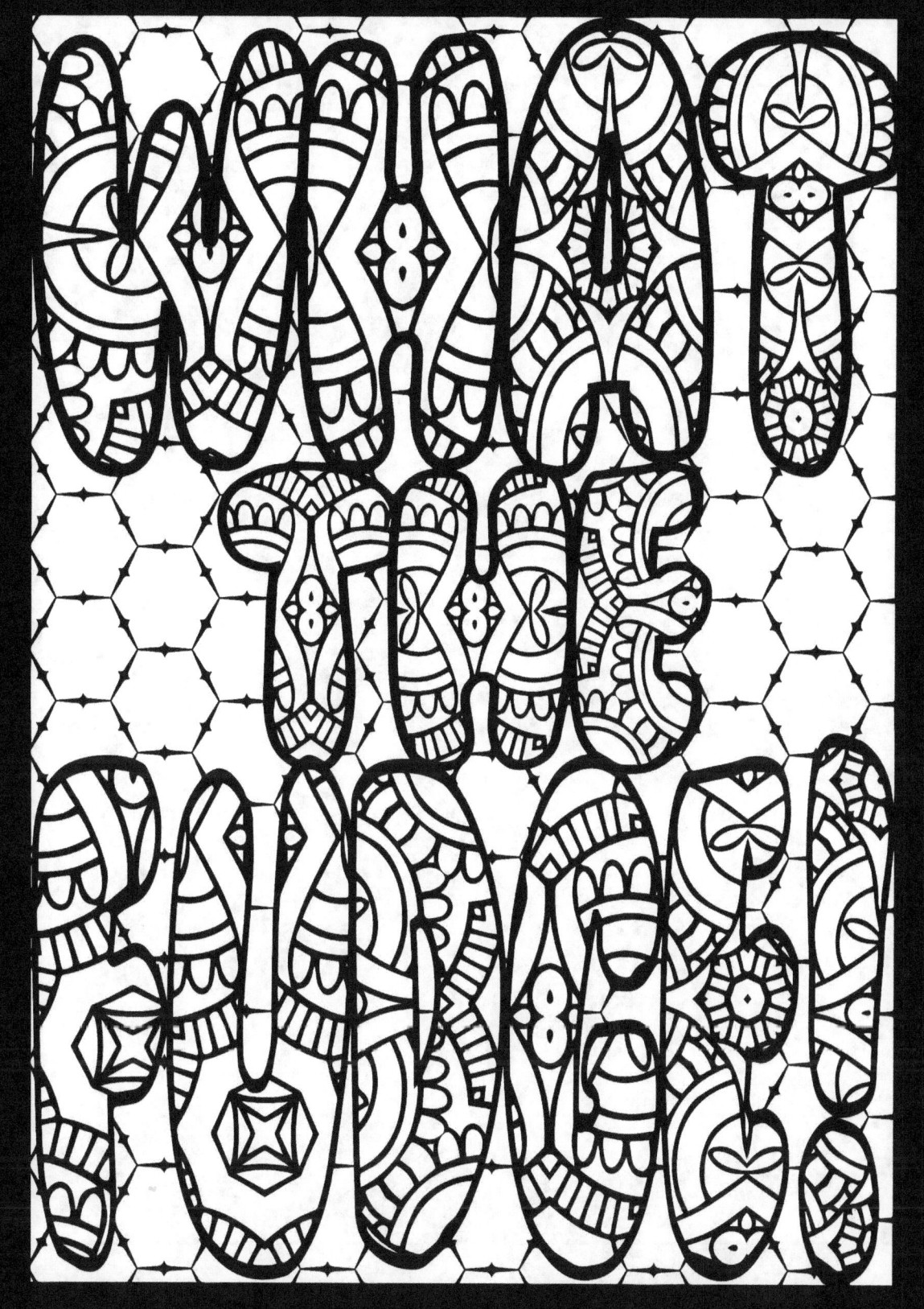

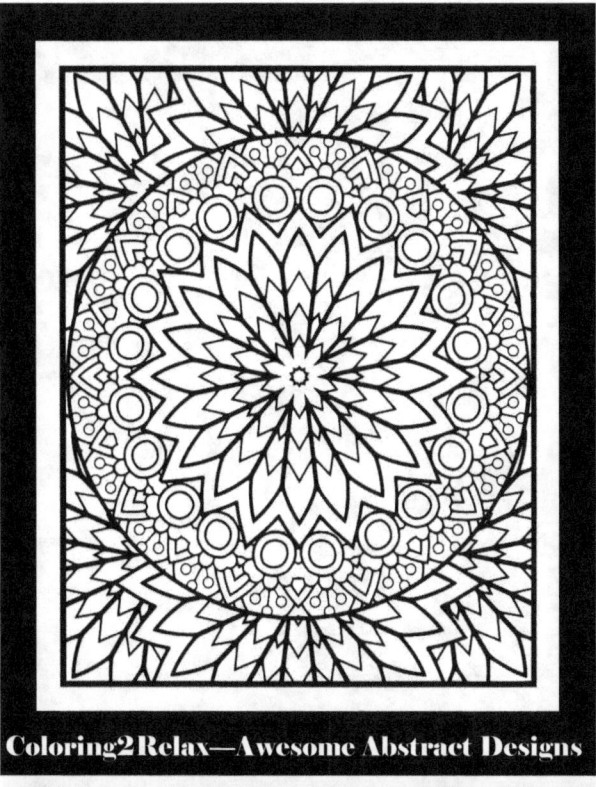
Coloring2Relax—Awesome Abstract Designs

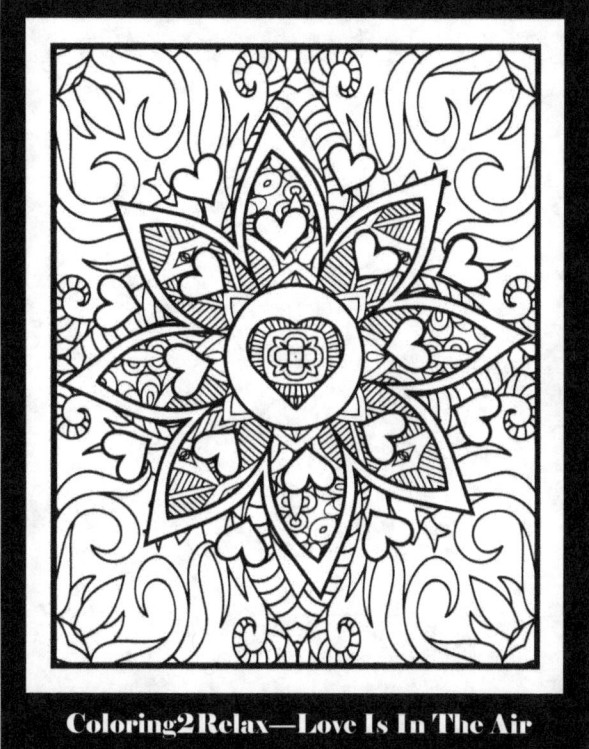
Coloring2Relax—Love Is In The Air

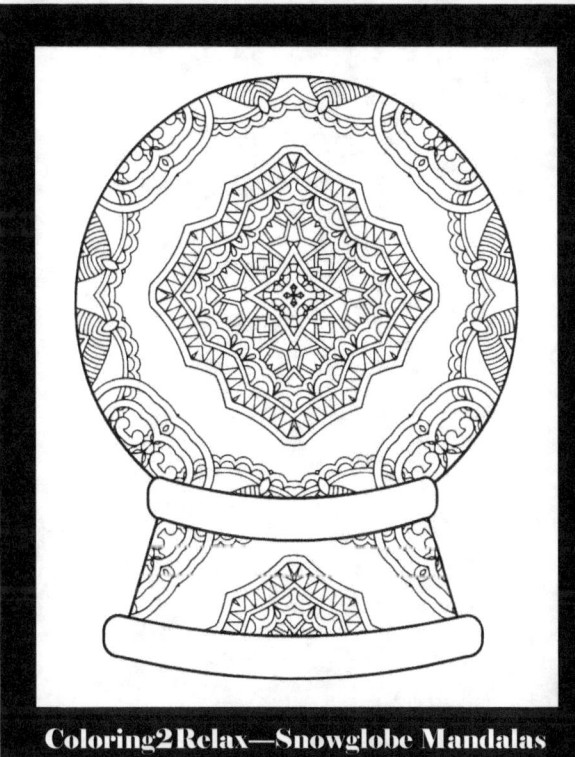
Coloring2Relax—Snowglobe Mandalas

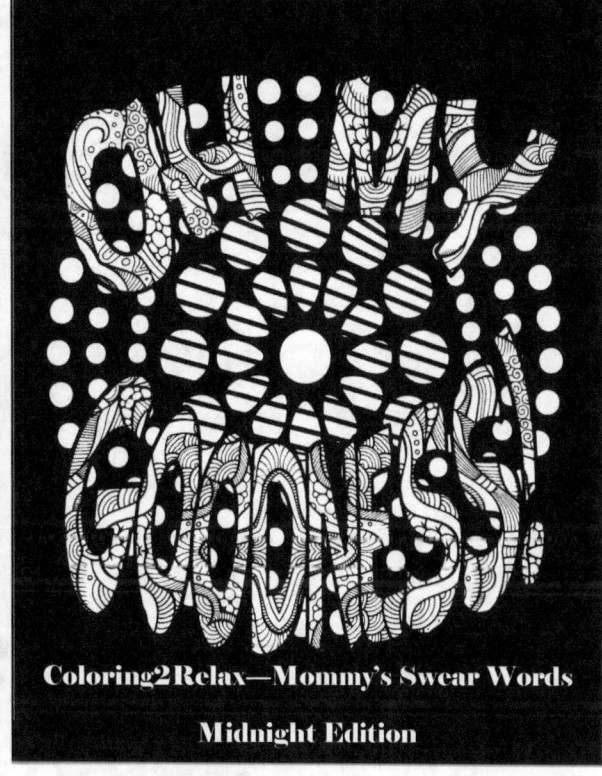
Coloring2Relax—Mommy's Swear Words Midnight Edition

Samples of Coloring Pages from some of our most popular Adult Coloring Books. Please visit our website, www.coloring2relax.com to shop more of our Adult Coloring Books and Journals. And don't forget your Freebies while you are there!

Coloring Practice Page

Practice blending & Shading, try new colors, test markers & gel pens, decide on color palettes or add color palettes you want to use later

Coloring Practice Page

Practice blending & Shading, try new colors, test markers & gel pens, decide on color palettes or add color palettes you want to use later

Coloring Practice Page
Practice blending & Shading, try new colors, test markers & gel pens, decide on color palettes or add color palettes you want to use later

Coloring Practice Page

Practice blending & Shading, try new colors, test markers & gel pens, decide on color palettes or add color palettes you want to use later

Blank Page

Pull out and use under the page you are coloring for added protection against bleed through and denting.

Blank Page

Pull out and use under the page you are coloring for added protection against bleed through and denting.

Blank Page

Pull out and use under the page you are coloring for added protection against bleed through and denting.

www.ingramcontent.com/pod-product-compliance
Lightning Source LLC
Chambersburg PA
CBHW081122180526
45170CB00008B/2961